THE GAY ICON'S

GUIDE TO LIFE

THE GAY ICON'S
GUIDE TO LIFE

MICHAEL JOOSTEN

ART BY PETER EMMERICH

weldon**owen**

CONTENTS

Success 88

Style 104

Aging 120

Goals 134

Using Your Voice 150

INTRODUCTION

IF LIFE HAD ITS OWN GPS SYSTEM, navigating it would be a far less stress-inducing slog than it actually is. Alas, life is a disorganized route of trailways where you don't always get to pick your preferred path. It's at times a smoothly paved highway allowing for thrilling speeds and a wide-open horizon of possibility; at other times, it's a pot-filled dirt road unforgivably thrashing you around as you try and minimize the amount of roadkill you leave in your wake. But there is something even more knowledgeable and dependable than a GPS, and that's . . . a Gay Icon!

Nobody understands the triumphs and defeats, the loves and losses, and the beauty and Botox of life better than the Gay Icon. By serving the world a never-ending conveyor belt of their talent, style, ambition, intelligence, confidence, wit, and heart, these global treasures are the sage keepers of the most indispensable life advice you will ever encounter.

Those words of wisdom from your parents . . . hard pass. That advice from the teacher who thought you were "a pleasure to have in class" and saw you as the hope of the future . . . no, ma'am. Oh, and that friend of yours who always knows just the right thing to say . . . I found out they actually hooked up with that person you like, so ditch them altogether. But the Gay Icons? Oh, honey, have they got you covered.

Within these pages you'll find the priceless musings of Emmy® winners, Grammy® winners, Oscar® winners, Tony® winners (this book is a literal EGOT), A-list movie stars, television legends, and fashion royalty. So, if you're lost, have missed your exit, or are stuck in traffic (just a disclaimer that these are all metaphors, as the following pages cannot actually help you with any of those issues), fear not. This book is the navi-GAY-tion system for life that you have been waiting for!

DATING & RELATIONSHIPS

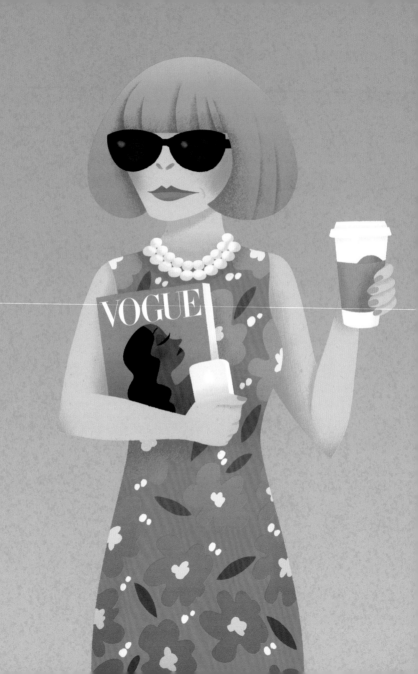

"It would be a mistake to think something is wonderful just because it looks great."

ANNA WINTOUR

"God and I have a great relationship . . . but we both see other people."

DOLLY PARTON

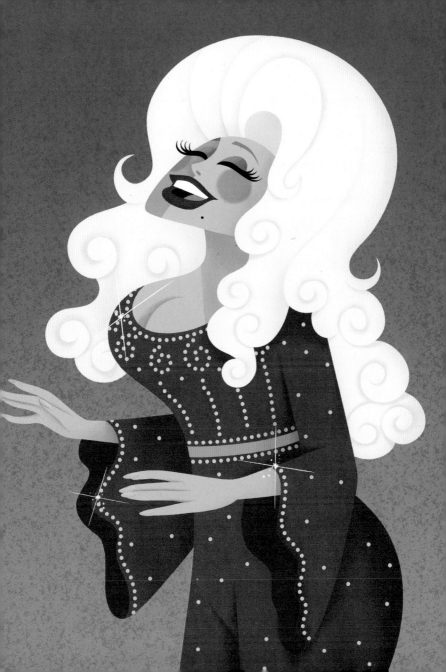

"Once you wake up and smell the coffee, it's hard to go back to sleep."

FRAN DRESCHER

"I mean,
it is the perfect
situation to really
love someone
to death and
want to rip their
clothes off at the
same time,
isn't it?"

GEORGE MICHAEL

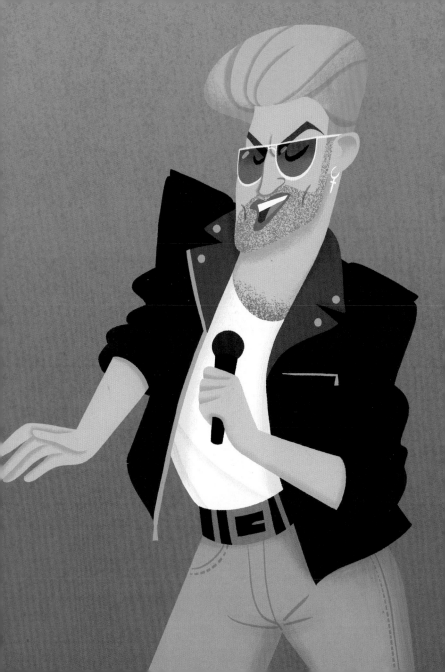

"Sometimes love
doesn't come
to us. We have
to go out hunting.
It's like pigs
looking for truffles.
It's called dating."

PATTI LUPONE

"Love is like a brick. You can build a house, or you can sink a dead body."

LADY GAGA

"Fight for that standing ovation at the end of the night. If you do something wrong, the domino effect is chaotic."

RICKY MARTIN

"Don't be so familiar. Close the door and keep them guessing."

CELINE DION

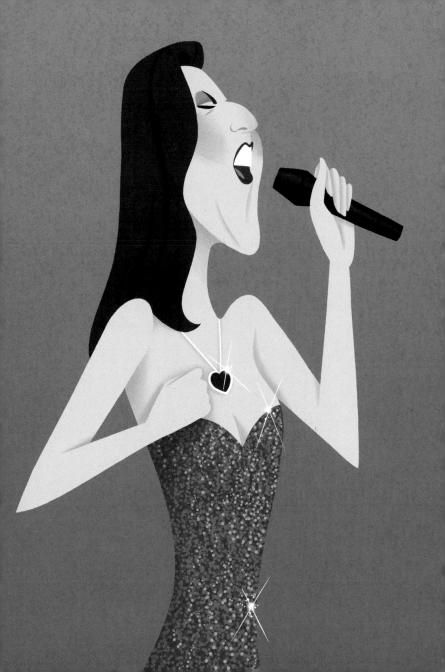

"Never let your heart take precedence over reason, otherwise you will have problems."

WHITNEY HOUSTON

SEX

"I don't know where I learned elephants like their tongues slapped. Whatever turns you on."

BETTY WHITE

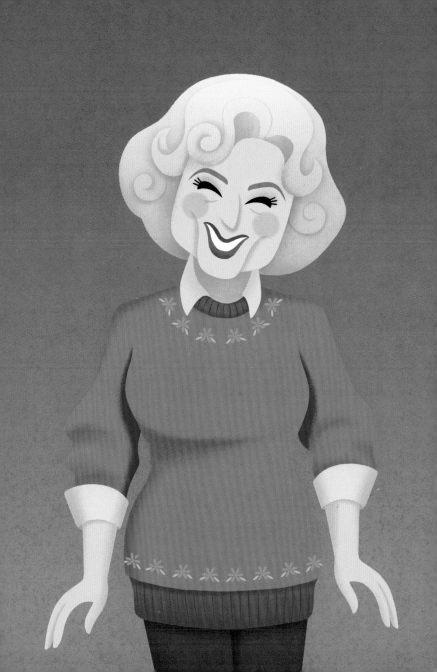

"I think people should be free to engage in any sexual practices they choose; they should draw the line at goats, though."

SIR ELTON JOHN

"Good sex is like good bridge. If you don't have a good partner, you'd better have a good hand."

MAE WEST

"I think it's great if a guy has a good-sized package."

JANET JACKSON

"Every time that I hear the orchestra tuning up, I get chills all over my body. You know, catharsis after catharsis. It's better than sex!"

ROSIE O'DONNELL

SELF-ESTEEM

"I am simple, complex, generous, selfish, unattractive, beautiful, lazy, and driven."

BARBRA STREISAND

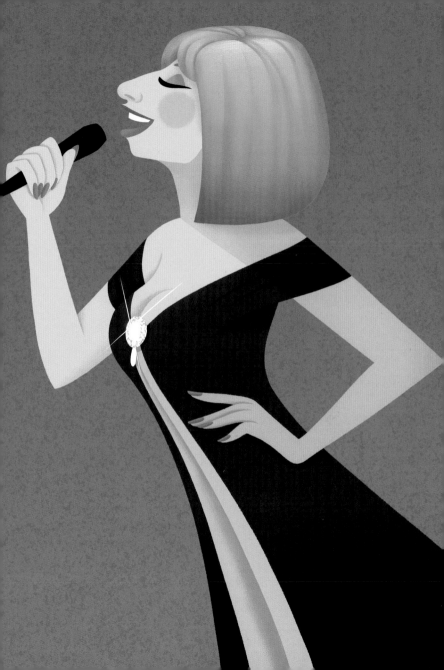

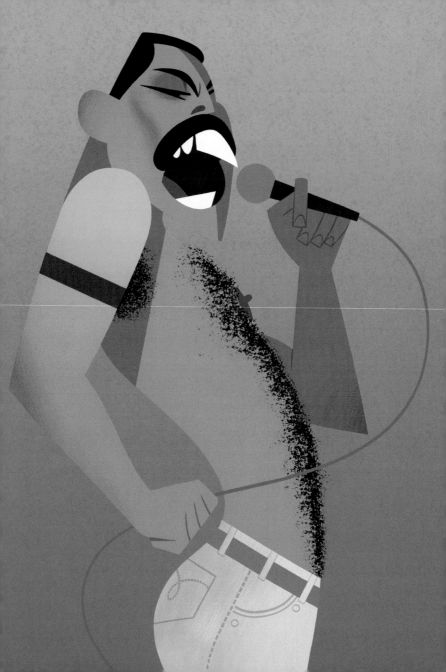

"The reason we're successful, darling? My overall charisma, of course."

FREDDIE MERCURY

"It's a shame to call somebody a 'diva' simply because they work harder than everybody else."

JENNIFER LOPEZ

"Never be a second-rate version of someone else; be a first-rate version of yourself."

JUDY GARLAND

"I'm tough, I'm ambitious, and I know exactly what I want. If that makes me a bitch, okay."

MADONNA

"Don't waste so much time thinking about how much you weigh. There is no more mind-numbing, boring, idiotic, self-destructive diversion from the fun of living."

MERYL STREEP

"I fell out of the womb and landed in my mother's high heels."

LESLIE JORDAN

"People are
going to
have opinions
about you ...
but the only one
that matters
is yours."

BRITNEY SPEARS

If you ain't wowin' the crowd,
were you ever really there?

"I don't leave a room unless I leave a smile."

JENIFER LEWIS

"I think women should get plastic surgery, I think men should get plastic surgery, I think dogs should get plastic surgery. Go out there and look your best."

RUE McCLANAHAN

"Sometimes,
folks make us feel
strange, but we're
not strange.
And those folks—
they'll just
have to catch up."

SYLVESTER

"The reality is: sometimes you lose. And you're never too good to lose. You're never too big to lose. You're never too smart to lose. It happens."

BEYONCÉ

"You just do it. You force yourself to get up. You force yourself to put one foot before the other, and goddamn it, you refuse to let it get to you. You fight. You cry. You curse. Then you go about the business of living. That's how I've done it. There's no other way."

ELIZABETH TAYLOR

Just like someone who has taken a vow of celibacy . . . you can't please everyone

"It's a sign of your worth sometimes if you're hated by the right people."

BETTE DAVIS

"No object is so beautiful that, under certain conditions, it will not look ugly."

OSCAR WILDE

"Reality is something you rise above."

LIZA MINNELLI

Don't panic ... your story will always have sequels and reboots

"I kind of have this mentality that says, 'everything will work out in the end. And if it's not working out, it's not the end.'"

RUPAUL

"I do believe there's a heaven. I do believe that God has given me the resilience and the survival skills to withstand the chiffon trenches."

ANDRÉ LEON TALLEY

Get out there and do the damn thing

"Always give them the old fire, even when you feel like a squashed cake of ice."

ETHEL MERMAN

"Whenever you're trying something new, it's always going to get some kind of bad reception."

LIL NAS X

"Once in a while it's good to challenge yourself in a way that's really daunting."

ALAN CUMMING

"One of the hardest things in life to learn is which bridges to cross and which bridges to burn."

OPRAH WINFREY

"My former
bullies pay extra
to come backstage
and meet me
after shows,
and I pretend not
to know them
in front of their
friends."

MARGARET CHO

"I don't know if it's naivete or just narcissism, but I start out with this notion that I can do anything. It's not until I get into it that I realize what I've thrown myself into, and then I will do anything not to humiliate myself. And that, I think, is the secret to my success."

MICHELLE PFEIFFER

"The one thing that has helped sustain my career as an actress and a comedian is that people generally view me as fundamentally stupid."

JENNIFER COOLIDGE

"I think being optimistic is ensuring your success. If you start out saying 'I've got this problem,' or 'I'm angry at that,' you will not succeed."

GEORGE TAKEI

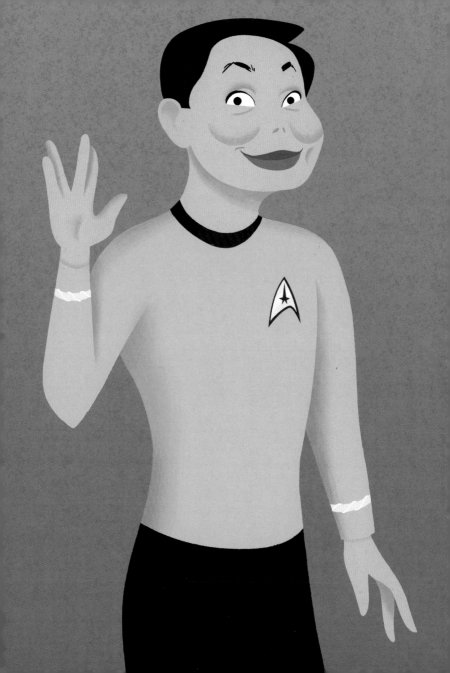

"Success is the sweetest revenge."

VANESSA WILLIAMS

*Sometimes people must
be put in their place*

"To those who voted for me, thank you. And to those who didn't, better luck next year!"

CATE BLANCHETT

"My third grade teacher
called my mother
and said, 'Ms. Cox,
your son is going to
end up in New Orleans
in a dress if we don't get
him into therapy.'
And wouldn't you know,
just last week I spoke
at Tulane University,
and I wore a lovely green
and black dress."

LAVERNE COX

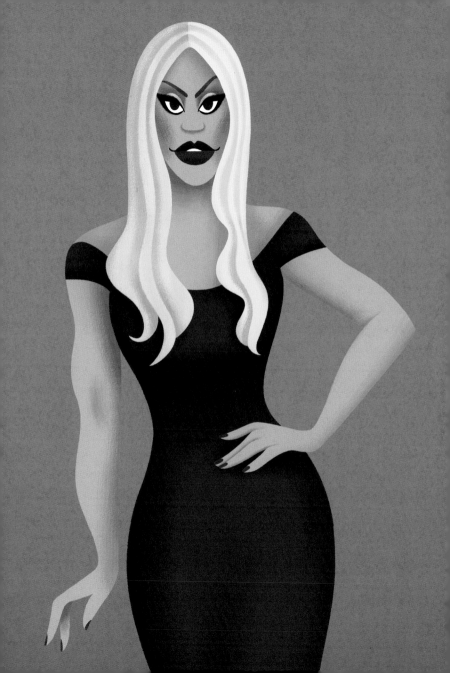

STYLE

There's nothing wrong
with being a size queen

"I'm a big woman.
I need big hair."

ARETHA FRANKLIN

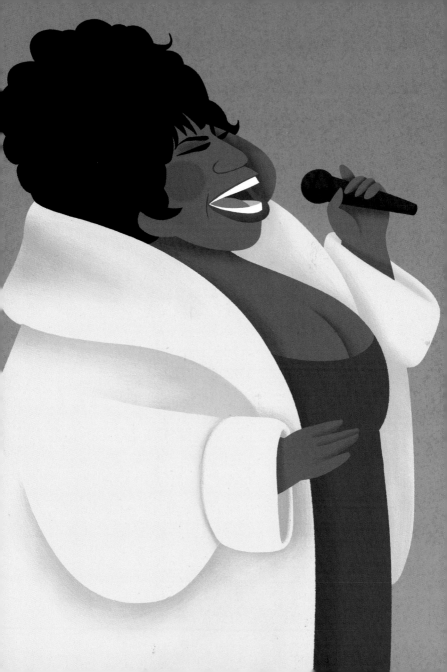

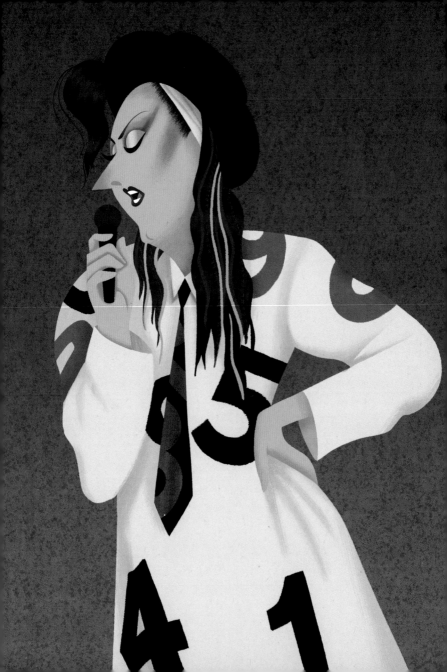

"I was never a wallflower— I put my head on the style chopping block."

BOY GEORGE

"On my darkest days, I wear my brightest colors."

CYNDI LAUPER

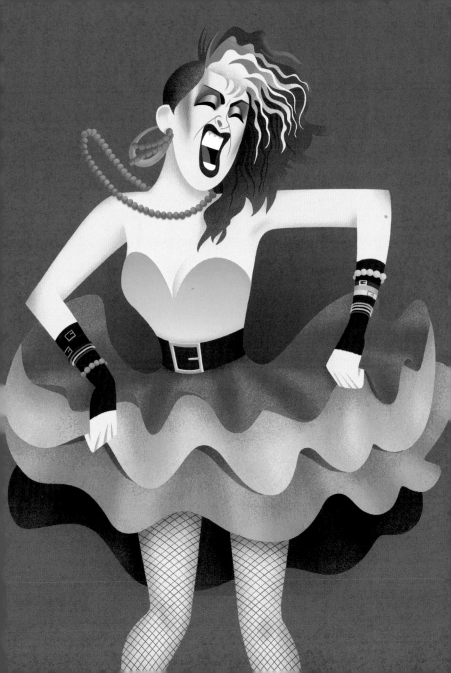

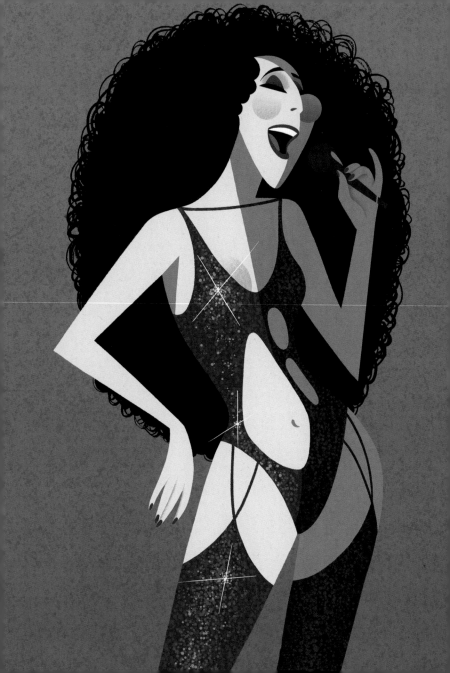

"I think that
the longer
I look good,
the better Gay
men feel."

CHER

Wear it while you can

"Does fashion matter? Always—though not quite as much after death."

JOAN RIVERS

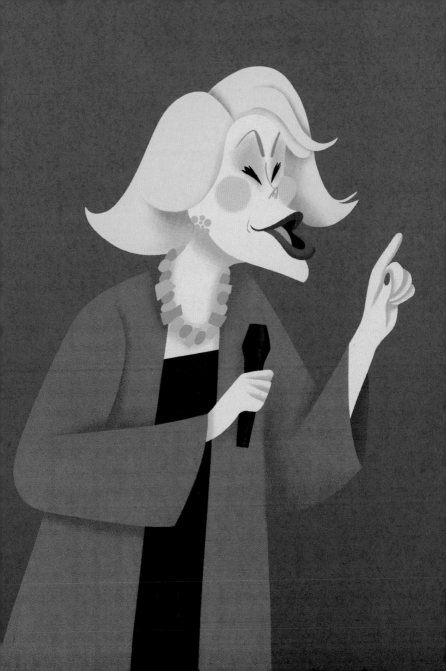

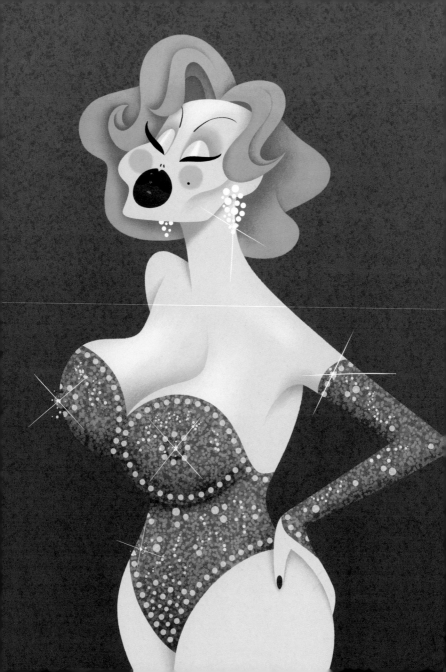

Stylistic wealth = Mental health

"Even though I know it's not always the case, I associate dressing up with mental stability."

AMANDA LEPORE

"I go feminine, I go masculine. I am both, actually."

GRACE JONES

"Send me flowers while I'm alive. They won't do me a damn bit of good after I'm dead."

JOAN CRAWFORD

It gets better

"The first

> *Embrace that you are in*
> *a constant state of evolution*

"I'm being myself, whatever the hell that is."

BEA ARTHUR

"Age does not bring you wisdom; age brings you wrinkles. If you're dumb when you're young, you're going to be dumb when you're old."

ESTELLE GETTY

"I bear no grudges. I have a mind that retains nothing."

BETTE MIDLER

"Every day of
my life is still
a campaign for
popularity,
or better yet, a
crowded funeral."

JOHN WATERS

GOALS

"I like Aurora, 'Sleeping Beauty,' because she's just sleeping and looking pretty and waiting for boys to come kiss her. Sounds like a good life—lots of naps and cute boys."

ARIANA GRANDE

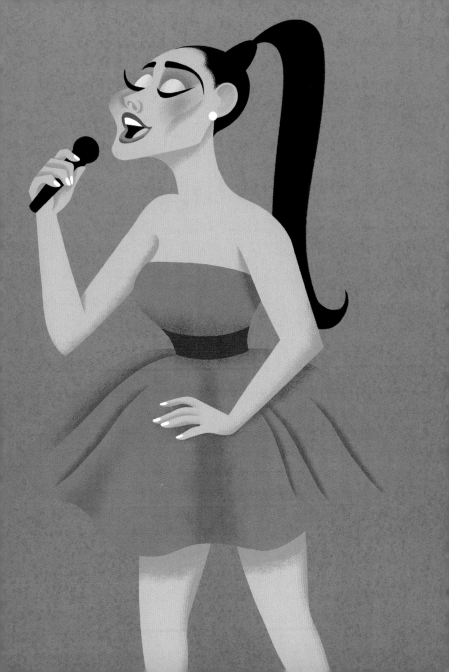

"I never said,
'Well, I don't
have this, and
I don't have that.'
I said, 'I don't have
this yet … but I'm
going to get it.'"

TINA TURNER

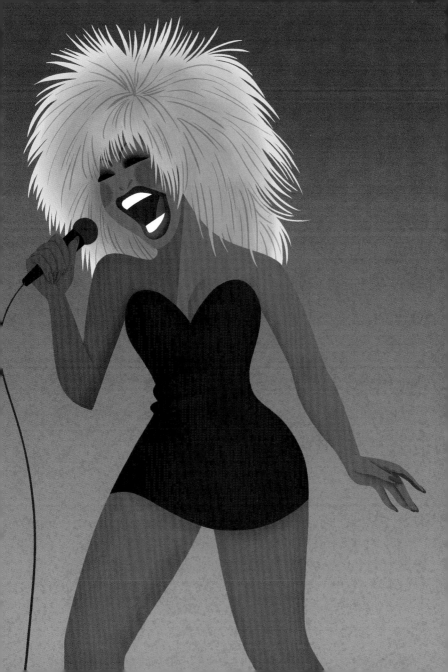

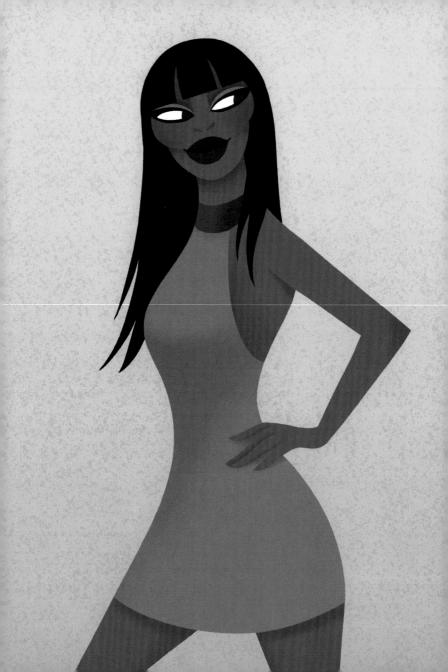

"If I'm told 'no,' then I find another way to get my 'yes.'"

NAOMI CAMPBELL

"I want to have two suitcases full of hair extensions by the time I'm forty."

BOWEN YANG

"It may be my rather puritanical upbringing at odds with my inborn laziness that makes me feel guilty at the end of the day unless I am able to point at some achievement. But this need be no more impressive than cooking a meal or going for a long walk."

SIR IAN McKELLEN

"I don't aspire to the middle. I aspire to the tip-tip-top of it all."

BILLY PORTER

"Instead of looking at the past, I put myself ahead twenty years and try to look at what I need to do now in order to get there then."

DIANA ROSS

Speak your truth . . . even if it's a lie

"I don't know her."

MARIAH CAREY

"If you have a big
voice, so be it.
But if you do
things quietly,
so be it.
It can be done."

ANGELA BASSETT

Spilled tea is timeless (unless it's about you—then it's simply born of jealousy)

"A drunk tongue is an honest one in my opinion."

ADELE

"It's easier to rip somebody to shreds while you're making them laugh."

WANDA SYKES

"Gwyneth Paltrow
names her kid Apple.
I'm not going to let
that stand."

KATHY GRIFFIN

It's imperative to give the Gays what they want

"I do dance music, and I can be pretty camp myself from time to time."

KYLIE MINOGUE

*Sugarcoating is for candy . . .
not words*

"Speak in extremes, it'll save you time."

DAVID BOWIE

CONCLUSION

THIS BOOK AND THE INCOMPARABLE
wisdom from the Gay Icons within it have now
prepared you to take on life's biggest challenges.
The knowledge that is now coursing through
your very being will guide you on your route to
slay, serve, shantay, hunty the house of life down
for the gods, boots!

In closing, let's get a bit esoteric, shall we?
I'd like you to think of yourself as a song. You're
the original version, the one you (and others) are
most familiar with. But just because that version
is a classic doesn't mean it has to sound the same
every time you hear it. The good thing about
us Gays is that we do love ourselves a remix.
And, what are we but a constant remixing of an
original? So, go forth with this newfound guide to
navigating life and use these treasured Gay Icons
as your producers/DJs, toss in a new bass line,
layer some vocals, and get a feature from the
hottest new artist you've never, ever heard of
who has 72 out of the top 100 singles on the
Billboard Hot 100 … and hit "play." It'll make
that car drive I mentioned in the introduction
a far easier ride.

A BIT ABOUT THE ICONS

ADELE The patron saint of brokenhearted ballads gives the Gays all the feelings with her music, while also giving them life with her lack of pretension and that fabulous cackle.

Listen: "Hometown Glory," "Rolling in the Deep," "Someone Like You," "Hello," "Easy on Me"

BEA ARTHUR Gays love sarcasm, and nobody did it better than stage and TV's Bea Arthur in the socially progressive classic sitcoms *Maude* and *The Golden Girls*. Her support of the Gay community was evident with statements like "Gays have the greatest taste and the greatest wit," and her charitable donations to LGBTQIA+ causes.

Watch: *Maude*, *The Golden Girls*, "Bosom Buddies" performance with Angela Lansbury at the 1988 Tony Awards

ANGELA BASSETT Her portrayal of Tina Turner earned her the highly coveted OGAC (Official Gay Approval Card) and established her as a permanent powerhouse talent. Also, cheekbones of the gods.

Watch: *What's Love Got to Do with It*, *Waiting to Exhale*, *How Stella Got Her Groove Back*, *Black Panther 2*

BEYONCÉ Launching the word "superstar" to entirely new heights, this Virgo goddess benevolently rules as divine Queen of the Beyhive, while serving slayage with each and every album and lewk.

Watch: *Lemonade*, *Homecoming*

Listen: "Crazy in Love," "Single Ladies," "Formation," "Drunk in Love," "Break My Soul"

DAVID BOWIE One of the greatest musical artists of all time, he utilized gender fluidity to capture the cultural zeitgeist and redefined the style scene, all while racking up hit songs that defined numerous eras.

Listen: "Is There Life on Mars," "Changes," "Under Pressure," "Fame," "Let's Dance"

Watch: *The Man Who Fell to Earth*, *Labyrinth*, *Moonage Daydream*

CATE BLANCHETT One of the most dynamic actresses of all time, she has consistently gooped the Gays with one transformative performance after another, while keeping her floors immaculately pristine (because the woman leaves no crumbs).

Watch: *Elizabeth*, *Blue Jasmine*, *Notes on a Scandal*, *Carol*, *Tár*

NAOMI CAMPBELL An empowered, barrier-breaking supermodel with the runway's most legendary walk and attitude, Naomi's influence and inspiring longevity serve as the benchmark for what it takes to become a living legend.

Watch: The Face

Read: *Naomi* (updated edition)

MARIAH CAREY She is a glamourous Bo Peep to all her lambs, and her epic vocal range and run of hits (including the most Billboard Hot 100 #1s of any female artist) have earned Mimi a cushy spot in the Diva Hall of Fame. In addition, she's the sommelier of good lighting.

Listen: "Vision of Love," "Emotions," "Make It Happen," "Hero," "One Sweet Day," "Fantasy," "Honey," "Touch My Body"

CAROL CHANNING With her signature raspy voice and infectiously optimistic showbiz razzmatazz, this legendary leading lady radiated joy and glamour from the Broadway stage to *The Love Boat* and became an imitation staple for countless drag performers.

Listen: *Hello, Dolly! Original Broadway Cast Recording* (1964)

Watch: *Thoroughly Modern Millie, Carol Channing: Larger Than Life*

CHER Reclining on a chaise among the top pantheon of Gay Icons owing to her singular no bullshit attitude, major fashion moments, and indisputable talent, she has conquered TV, music, and film, racking up massive successes in each.

Listen: "I Got You Babe," "If I Could Turn Back Time," "Believe," "Strong Enough"

Watch: *Mask, Silkwood, The Witches of Eastwick, Moonstruck*

MARGARET CHO She has broken boundaries as a Queer Asian female comic, and her willingness to make jokes about everything from her mother to her own genitalia proves that she is a major standout of her stand-up generation.

Watch: *I'm the One That I Want, Notorious C.H.O., 30 Rock*

JENNIFER COOLIDGE Her bubbly personality, comedic and dramatic chops, and trademark line delivery have led her to become an official Grand Marshal of the Gays (even though she once accused us of trying to murder her in *The White Lotus*).

Watch: *Best in Show, American Pie, Legally Blonde, The White Lotus*

LAVERNE COX She smashed through long-standing societal walls by virtue of her talent, fortitude, and advocacy, becoming the first openly trans person to earn an Emmy acting nomination. We stan.

Watch: *Orange Is the New Black, Disclosure, Inventing Anna*

JOAN CRAWFORD A silver-screen legend and noted wire-hanger oppositionist (immortalized in the camp biopic *Mommie Dearest*), her feud with Bette Davis is as legendary as some of her films.

Watch: *The Women, Mildred Pierce, Johnny Guitar, What Ever Happened to Baby Jane?*

ALAN CUMMING A Queer stalwart of stage, screen, television, and books, he has built an acclaimed career (*Spice World*, anyone?) without compromising being his authentic self.

Watch: *Circle of Friends, Romy and Michele's High School Reunion, Schmigadoon!*

BETTE DAVIS A one-of-a-kind talent in Hollywood's golden age, she was not averse to going against the grain. Also, she gave us one of the juiciest celebrity feuds in history (no matter what we say, Gays love drama).

Watch: *Dangerous, Jezebel, All About Eve, What Ever Happened to Baby Jane?*

CELINE DION This chest-pounding French-Canadian vocal powerhouse has the market cornered on ubiquitous power ballads thanks to her catalog of range-defying romantic megahits.

Listen: "Beauty and the Beast," "Because You Loved Me," "It's All Coming Back to Me Now," "My Heart Will Go On"

FRAN DRESCHER Combining her Queens-bred comedic chops and huge flair for style, she created *The Nanny*, descending the set's staircase in lewks that left the Gays kvelling each and every episode (insert her laugh here).

Watch: *This Is Spinal Tap, The Nanny, The Beautician and the Beast*

BOY GEORGE As an absolute one-of-a-kind Eighties pop star, Boy George upended the world with his gender-bending style, unapologetic makeup, and melodious hit songs, solidifying him as a rightful legend in both the music and style worlds.

Listen: "Karma Chameleon," "Do You Really Want to Hurt Me," "The Crying Game"

ARETHA FRANKLIN The Queen of Soul was a true DIVA (all caps intended) by giving us some of *the best* vocals of all time, as well as an ultimate fashion moment courtesy of her legendary hat at President Obama's Inauguration.

Listen: "R-E-S-P-E-C-T," "Chain of Fools," "Think," "Natural Woman," "Amazing Grace," "Freeway of Love"

JUDY GARLAND She was one of the greatest performers ever, and her work in film, music, and TV serves as a treasure trove of her mammoth and unequaled talent. Her classic song "Somewhere Over the Rainbow" has been an inspiration for generations of the LGBTQIA+ community. Also, massive bonus points to her for giving us Liza Minnelli.

Watch: *The Wizard of Oz, Meet Me in St. Louis, A Star Is Born, Judgment at Nuremberg*

Listen: *Judy at Carnegie Hall*

ESTELLE GETTY Pint-size, but able to pack a big punch with her no-filter line deliveries ("Picture it. Siciliy, 1922."), Getty's tiny—yet mighty—Sophia Petrillo loomed large on the classic sitcom *The Golden Girls*. She also made her mark on the Broadway stage, co-starring in Harvey Fierstein's Gay classic *Torch Song Trilogy*.

Watch: *Mask, The Golden Girls*

ARIANA GRANDE As the official spokeswoman of the high ponytail, she is a literal bop factory for Gays, with songs ready for the gym, the club, and the bedroom (not necessarily in that order).

Listen: "Break Free," "No Tears Left to Cry," "Thank U Next," "Side to Side," "7 Rings"

KATHY GRIFFIN Nobody skewers celebrity culture more than this redheaded spitfire, who has been spilling the tea and throwing the shade for decades … thus keeping all the Gays fed and happy.

Watch: *My Life on the D-List, Calm Down Gurrl, A Hell of a Story*

Read: *Official Book Club Selection: A Memoir According to Kathy Griffin*

WHITNEY HOUSTON Gays love the vocals of a true diva, and this diva could do it all—dance/pop, gospel, R&B, show tunes, soaring high notes, heartbreakingly tender ones. She literally gave us everything, and then some.

Listen: "I Wanna Dance with Somebody," "So Emotional," "How Will I Know," "Saving All My Love for You," "I Will Always Love You," "I'm Every Woman," "I Have Nothing," "Exhale (Shoop-Shoop)," "It's Not Right But It's Okay"

Watch: *The Bodyguard, Waiting to Exhale, Cinderella, The Preacher's Wife*

JANET JACKSON With a stratospheric career, she became one of music's biggest hitmakers and influencers, with a song catalog overflowing with the literal equivalent of Gay catnip.

Listen: "Control," "Nasty," "Rhythm Nation," "Escapade," "If," "Again," "That's the Way Love Goes," "Together Again"

SIR ELTON JOHN With a song catalog containing some of the most beloved music ever, this dynamic, hitmaking showman also started The Elton John AIDS Foundation to help fund research for a cure.

Listen: "Your Song," "Tiny Dancer," "Candle in the Wind," "Goodbye Yellow Brick Road," "Bennie and the Jets"

GRACE JONES Having built a modeling, singing, and acting career that celebrated her androgyny, boldness, and talent, this Studio 54 fixture endeared herself to the Gays with her signature live performances and unabashed self-confidence.

Listen: "Pull Up to the Bumper," "Slave to the Rhythm"

Watch: *Grace Jones: Bloodlight and Bami*

LESLIE JORDAN Responsible for getting millions through the pandemic with his humor and heart, and for keeping us in hysterics in his side-splitting role as Beverly Leslie on *Will & Grace*, he was truly a one-man joy factory.

Watch: *Will & Grace, American Horror Story, My Life Down the Pink Carpet, Call Me Kat*

LADY GAGA With her penchant for killer hooks, campy costumes, designer couture, and committed support of the LGBTQIA+ community, Lady Gaga's wild-child spirit has brought the bops, the ballads, and some of film's most enjoyable press tours.

Listen: "Just Dance," "Poker Face," "Paparazzi," "Born This Way," "A Million Reasons," "Shallow," "Allesandro" (which she dedicated to her Gay fans)

Watch: *A Star Is Born, House of Gucci*

CYNDI LAUPER Her quirky personality, thrift-store style, and steel pipes have endeared this singer-songwriter to those marching to the beat of their own drum, eventually singing what has become an LGBTQIA+ anthem*.

Listen: "Girls Just Wanna Have Fun," "She Bop," "Time After Time," "True Colors"*

AMANDA LEPORE Rising from the NYC club-kid scene to become the red-lipped glamour goddess of nightlife, she is one of the first openly trans fixtures of pop culture.

Look Up: Collabs with photographer David LaChapelle (*Addicted to Diamonds* and *Making Love*)

JENIFER LEWIS Hailed as The Mother of Black Hollywood, this dynamic diva has conquered Broadway, film, TV, and social media, proving sheshe has an endless and unstoppable supply of talent, humor, and energy.

Watch: *Jackie's Back, Black-ish, I Love That for You*

Read: *The Mother of Black Hollywood, Walking in My Joy*

LIL NAS X Shattering cultural norms for what a rapper can be, Lil Nas X has blazed his own trail right up to the top of the charts by unapologetically celebrating who he is and what he has to offer the world.

Listen: "Old Town Road," "Montero (Call Me by Your Name)," "Industry Baby," "That's What I Want"

JENNIFER LOPEZ From battling anacondas to spinning on a stripper pole at the Super Bowl, if it's a triple threat you want, then look no further than J. Lo's hit movies, smash songs, and killer moves, which wow every single crowd.

Listen: "If You Had My Love," "Waiting for Tonight," "Let's Get Loud," "Jenny from the Block," "I'm Real"

Watch: *Selena, Out of Sight, Hustlers*

PATTI LUPONE Broadway's boldest diva and empress of theater etiquette is one of the greatest gifts the Gay gods bestowed upon us mere Gay mortals (not to mention her canonic visits to *Watch What Happens Live*).

Listen: *Patti LuPone Live at Mouches, Evita, Les Misérables, Anything Goes, Sunset Boulevard*

Watch: *American Horror Story, Hollywood, Agatha: Coven of Chaos*

Read: *Patti LuPone: A Memoir*

MADONNA As an unyielding ally to the LGBTQIA+ community, the best-selling female recording artist of all time and the Queen of Pop built the official playbook on music superstardom and created a staggering number of legendary smash hits and iconic music videos that have woven themselves into the very fabric of Gay culture.

Listen: EVERYTHING! ABSOLUTELY EVERYTHING!

Watch: 1984 and 1990 VMA performances, *Desperately Seeking Susan, Dick Tracy, A League of Their Own, Evita*

SIR IAN McKELLEN From the West End to Broadway and TV to film, few careers of any actor (let alone an openly Gay one) span the breadth of Sir Ian McKellen's, who has played everyone from Shakespeare's tortured Macbeth to Tolkien's beloved Gandalf.

Watch: *Richard III, King Lear, Gods & Monsters, X-Men, The Lord of the Rings* trilogy, *Vicious*

FREDDIE MERCURY With that killer combo of vocal range, sexy swagger, and unapologetic confidence, the lead singer of Queen cemented his legacy as one of music's most talented and charismatic front men. After his passing, the band created The Mercury Phoenix Trust, which funds programs around the world to raise awareness about HIV/AIDS.

Listen: "Bohemian Rhapsody," "We Are the Champions," "We Will Rock You," "Crazy Little Thing Called Love," "Don't Stop Me Now," "Another One Bites the Dust"

RICKY MARTIN Since he hit American TV screens at the 1999 Grammys, the nation's loins have never been the same thanks to his megawatt supply of charm, looks, hips, and hits. In 2010, he came out as Gay, solidifying his place in the LGBTQIA+ community.

Listen: "La Copa de la Vida," "Livin' La Vida Loca," "She's All I Ever Had," "She Bangs"

ETHEL MERMAN She starred in some of Broadway's most classic musicals (*Anything Goes, Annie Get Your Gun, Gypsy*) and her brassy belt (that could rival a foghorn) and matching personality have echoed across decaaaaaaaaaaaaaaaaaaaaaaaaaaaades.

Listen: *Gypsy, Songs She Made Famous, The Ethel Merman Disco Album*

Watch: *Call Me Madam*

RUE McCLANAHAN Every group of friends needs its vixen, and on *The Golden Girls*, Rue McClanahan's mix of genteel Southern charm and appetite for sexual conquests (which many Gay men identified with) is carnal comedic gold. She garnered further Gay adoration due to her work with Del Shores and as Madame Morrible in Broadway's *Wicked*.

Watch: *Maude, Mama's Family, The Golden Girls*

GEORGE MICHAEL From his start in the duo Wham! to his mega-successful solo career, he radiated sex appeal, while also being able to back that up with equal skill as a brilliant singer-songwriter. Although forced out of the closet, George fully and unapologetically embraced his sexuality and worked on behalf of many LGBTQIA+ charities.

Listen: "Careless Whisper," "Father Figure," "Faith," "Freedom," "Too Funky"

Watch: *Faith, Freedom, Too Funky, Don't Let the Sun Go Down on Me* (with Elton John)

BETTE MIDLER Brassy, sassy, and multitalented, this icon got her start in the Gay bathhouses of NYC. Gays happily pledge allegiance to that trifecta, which is why The Divine Miss M has been anointed as one of our all-time greats.

Watch: *The Rose, Beaches, For the Boys, Hocus Pocus, The First Wives Club*

Listen: "Miss Otis Regrets," "The Rose," "Stay with Me," "Wind Beneath My Wings"

LIZA MINNELLI Despite being the offspring of iconic parents (Judy Garland and Vincente Minnelli), Liza carved her own path to Broadway, film, and television, solidifying herself—much like her mother—as one of the best live entertainers ever.

Watch: *The Sterile Cuckoo, Cabaret, Liza with a Z, Arthur, Stepping Out*

Listen: *Flora the Red Menace, The Act, The Rink*

KYLIE MINOGUE Australia's greatest musical export since the didgeridoo, Kylie's pop prowess has yielded homo-endorsed dance hits that she keeps throwing at us like an array of gorgeously sequined boomerangs.

Listen: "Can't Get You Out of My Head," "Hearts," "All the Lovers," "Get Out of My Way," "Into the Blue"

ROSIE O'DONNELL *The Rosie O'Donnell Show* created an after-school gateway to celebrity, Broadway, and pop culture, showing little Gays all the joy and magic entertainment has to offer (not to mention her long-standing advocacy for same-sex adoption). Also, she's besties with Madonna (a major flex).

Watch: *A League of Their Own, Sleepless in Seattle, The Flintstones, I Know This Much Is True*

DOLLY PARTON The Queen of Country is one of the greatest songwriters of all time and has garnered the love of millions thanks to her music, kindness, and sense of humor. Special shout-out to the wigs and heels.

Listen: "Jolene," "I Will Always Love You," "Here You Come Again," "9 to 5," "The Grass Is Blue"

Watch: *9 to 5, Steel Magnolias, Joyful Noise*

MICHELLE PFEIFFER Hailed as the most beautiful woman in the world (with talent that equals her beauty), she has a mix of steel and vulnerability that gave the Gays their first glimpse of fetishism and kink via her unsurpassable Catwoman. Meow!

Watch: *Grease 2, Scarface, Dangerous Liaisons, The Fabulous Baker Boys, Batman Returns, Hairspray*

BILLY PORTER Category is … triple threats: With boundary-shattering performances on Broadway and TV (where he became the first openly Gay Black man to win an Emmy for lead actor in a drama) he brings the goods to the stage, the camera, and the red carpet, dahling.

Watch: *Kinky Boots, Pose, Cinderella*

JOAN RIVERS She was an undeniable pioneer for women in stand-up, a lover of gossip, and her take-no-prisoners red carpet commentary (where she coined the iconic phrase "Who are you wearing?") solidified her as one of the Gay's biggest patron saints.

Watch: *Spaceballs, A Piece of Work, Don't Start with Me*

DIANA ROSS The Queen of Motown's rise from girl-group songstress to full-fledged solo stardom is one for the history books, seeing as how she dominated the charts, the big screen, and the fashion world.

Listen: "Stop! In the Name of Love," "Baby Love," "Upside Down," "I'm Coming Out," "Endless Love"

RUPAUL Mother has arrived, and she's brought the mainstreaming of drag right along with her. Serving as hope and inspiration for anyone wanting to embrace their truest self, Mama Ru reigns supreme.

Listen: "Supermodel," "Cover Girl," "Jealous of My Boogie," "Peanut Butter," "Sissy That Walk," "U Wear It Well"

Watch: *Drag Race, A Very Brady Movie*

BRITNEY SPEARS This culture-resetting pop princess had the Gays in the palm of her hand the second she strutted down that hallway of lockers, and she then followed it up with a tidal wave of hits, classic music videos, and signature choreo.

Listen: "Baby One More Time," "Oops! …I Did It Again," "Toxic," "Till the World Ends," "Work Bitch"

MERYL STREEP Considered the greatest actress of all time, she has a chameleon-like ability to portray a wide variety of roles, keeping the Gays riveted (since we love eras and costume changes).

Watch: *Kramer vs. Kramer, Sophie's Choice, Silkwood, Death Becomes Her, The Devil Wears Prada*

BARBRA STREISAND Babs—one of stage, screen, and recording's most successful, acclaimed, and beloved artists of all time—has kept audiences in awe for decades and in the hearts of Gays by virtue of those eternally bow-down-worthy pipes. Hello, gorgeous!

Listen: "Don't Rain on My Parade," "People," "Jingle Bells," "The Way We Were"

Watch: *Funny Girl, The Way We Were, Yentl, The Prince of Tides*

WANDA SYKES Whether in her own stand-up specials, film, or TV roles, she has spunk, no-nonsense delivery, and impeccable timing, making her one of the most reliable comics to watch when you need a laugh.

Watch: *Wanda Sykes: I'ma Be Me, Wanda Sykes: Not Normal, The Other Two*

SYLVESTER An absolute serve with a combo of flamboyancy, androgyny, and a powerhouse falsetto for the gods, this trailblazer gave the disco era (and music in general) some of the best dance tracks ever.

Listen: "Dance (Disco Heat)," "You Make Me Feel Mighty Real," "I (Who Have Nothing)"

Watch: *Love Me Like You Should: The Brave and Bold Sylvester*

GEORGE TAKEI This legend launched into pop culture history with a barrier-breaking role of rare Asian representation in the late 1960s on TV's *Star Trek*, by coming out in his late sixties, and by having a hugely popular social media profile where he mixes sass with poignancy.

Watch: *Star Trek* (TV, 1966–1969), *Star Trek* (Films, 1979–1991)

ANDRÉ LEON TALLEY A fashion titan, he became *Vogue*'s first-ever Black creative director, followed by his tenure as the maga-zine's editor-at-large. He's also responsible for ushering the phrase "dreckitude" into the lexicon.

Read: *The Chiffon Trenches*

Watch: *The Gospel According to André*

ELIZABETH TAYLOR One of the most famous—and glamorous—women in history, she was also an early advocate for the AIDS crisis and created The Elizabeth Taylor AIDS Foundation to help fund research for a cure.

Watch: *A Place in the Sun*, *Cat on a Hot Tin Roof*, *Who's Afraid of Virginia Woolf?*

TINA TURNER One of the best to ever do the damn thing, the empowering Queen of Rock's strength, fortitude, and talent secured her status as an absolute goddess with decades' worth of classic hits.

Listen: "A Fool in Love," "River Deep, Mountain High," "Proud Mary," "What's Love Got to Do with It," "Private Dancer"

JOHN WATERS Campy, funny, and unapologetic, with a stellar eye for kitsch, this writer/director has created some of cinema's Queerest cult classics of all time and maintains the world's teeniest mustache.

Watch: *Pink Flamingos*, *Female Trouble*, *Polyester*, *Hairspray*, *Cry Baby*, *Serial Mom*

MAE WEST This curvy, blonde, and bawdy actress/writer was known for her sex-positive persona—at a time when that mindset was considered taboo—and for being personally responsible for some of cinema's most memorable double entendres.

Watch: *I'm No Angel*, *She Done Him Wrong*, *My Little Chickadee*, *Mae West: Dirty Blonde*

BETTY WHITE A pioneer in the early days of radio and TV, this comedic legend starred in two classic sitcoms and became an indisputable national treasure. Long live St. Olaf!

Watch: *The Mary Tyler Moore Show*, *The Golden Girls*, *The Proposal*

OSCAR WILDE Considered to be one of the very first outspoken Gay icons based on his plethora of incisively accurate quips, this nineteenth-century novelist, poet, and playwright truly was the founding father of Gay witticism, which is why his works are still feted to this very day.

Read: *The Picture of Dorian Gray*, *The Importance of Being Earnest*, *The Ballad of Reading Gaol*

VANESSA WILLIAMS With a one-of-a-kind career spanning the Miss America pageant, film, TV, music, and Broadway, she is the true definition of multitalented. Also, her use of the side-eye is a legitimate art form.

Listen: "Dreamin'," "Running Back to You," "Save the Best for Last," "Love Is," "The Sweetest Days," "Colors of the Wind"

Watch: *Soul Food*, *Dance with Me*, *A Diva's Christmas Carol*, *Ugly Betty*

OPRAH WINFREY A beloved and inspirational talk-show host (who dedicated entire episodes to vital LGBTQIA+ topics dating back to the late Eighties), producer, actress, and lover of bread, this billionaire mogul has created a self-made empire with her talk show, OWN TV network, Oprah's Book Club, *O Magazine*, and juicy celebrity interviews.

Watch: *The Oprah Winfrey Show: 20th Anniversary Collection*, *The Color Purple*, *Beloved*

ANNA WINTOUR As the most powerful person in fashion, she is given absolute respect by Gays, and her signature dark shades and bobbed hairstyle leave us snapping (and in a bit of fear).

Watch: *The September Issue*, *The First Month in May*

BOWEN YANG An *SNL* fan and critic favorite, he already channels legendary and unapologetically Queer characters, including the irritated Iceberg that sunk the *Titanic*, a fed-up Oompa Loompa, and a fierce-ass daddy longlegs.

Watch: All the characters just mentioned on *Saturday Night Live*, *Fire Island*

ACKNOWLEDGMENTS

First, I'd like to thank the Academy ... oh, wait ... wrong speech. Big Gay thanks to Kevin for opening this door and leading me through it with care and kindness; Karyn for seeing the project's potential and captaining this metaphorical ship with such enthusiasm; Peter for jumping on board with his dynamic art that I'll never stop fangirling over; Frances for the years of building up my confidence so that I could even attempt something like this; and to my personal Gay icons—Ricky, Louis, Anthony, Patrick, Alex, and Ray—thank you for helping keep this train, and me, on the tracks ... this is for you.

—Michael Joosten

Love always to my husband Jared, for continually motivating me and being a constant source of strength and love.

XO, P

weldon**owen**

an imprint of Insight Editions
P.O. Box 3088
San Rafael, CA 94912
www.weldonowen.com

CEO Raoul Goff
VP Publisher Roger Shaw
Editorial Director Katie Killebrew
Senior Editor Karyn Gerhard
VP Creative Chrissy Kwasnik
Art Director Allister Fein
VP Manufacturing Alix Nicholaeff
Sr Production Manager Joshua Smith
Sr Production Manager, Subsidiary Rights
Lina s Palma-Temena

Weldon Owen would also like to thank Jon Ellis, Karen Levy, and Margaret Parrish for their work on this project.

Text © 2024 Michael Joosten
Illustrations © 2024 Peter Emmerich

ISBN: 979-8-88674-080-6

Manufactured in China by Insight Editions
10 9 8 7 6 5 4 3 2 1

ROOTS of PEACE REPLANTED PAPER

Insight Editions, in association with Roots of Peace, will plant two trees for each tree used in the manufacturing of this book. Roots of Peace is an internationally renowned humanitarian organization dedicated to eradicating land mines worldwide and converting war-torn lands into productive farms and wildlife habitats. Roots of Peace will plant two million fruit and nut trees in Afghanistan and provide farmers there with the skills and support necessary for sustainable land use.